# ON JOHN MUIR TRAIL

## the confluence of four live on an epic journey

# CHARLES A. RAGUSE

Printed in the United States of America

ISBN:   Softcover                    978-1-63871-436-1
        eBook                        978-1-63871-437-8

Republished by: PageTurner Press and Media LLC
Publication Date: 08/13/2021

**To order copies of this book, contact:**

PageTurner Press and Media
Phone: 1-888-447-9651
info@pageturner.us
www.pageturner.us

# ON JOHN MUIR TRIAL
## The Confluence of Four Live on an Epic Journey

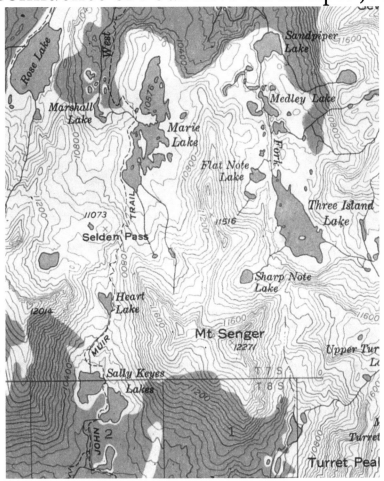

Photographs and Narrative by
Charles A. Raguse with

Technical Assistance by Paul D. Raguse

A SMALL SECTION OF THE ORIGINAL TRAIL

# Table of Contents

# PART 1

# GENESIS OF A HIGH-MOUNTAIN TRIP

For me, Genesis was when I innocently walked down the lower floor of the (then) Agronomy Department, in Hunt Hall on the University of California's Davis Campus. As I passed by James E. (Jim) Street's office, I noticed that Jim was in conversation with a couple of other men. One was Anthony (Tony) Holland, a visiting scientist in the department charged with solving the problem of ineffective nodulation of annual legumes sown for improvement of foothill pastures.

The other was Burgess L. (Bud) Kay, another member of the (then) Agronomy Department. There was really nothing out of the ordinary about these three people (all known to me) having a casual conversation in somebody's office.

But at the exact moment I was passing that open door, I overheard Bud saying to Jim "I doubt that it's wise to ask Charlie to go – he might not be competent enough to take on that kind of a venture."

Over five and a half decades later, I can't be sure whether I knew anything about the high-mountain pack trip he was planning, which would include Tony Holland, from Australia, Jim's brother, John ("Brother John") Street, who would soon be arriving in Davis from his home in Hawaii But I can still, in my "mind's eye" see that little group. I had only been hired a year ago, so for sure I was a greenhorn about how to navigate any place in California that wasn't flat, like the Middle West where I born, raised, and got my education.

And I was hearing "I wouldn't take Charlie along; that could be a big mistake."

But in the end, Jim invited me along anyway. Perhaps he had no choice. Perhaps those in that room realized that I had overhead Bud Kay's innocent remark. "So now", they said. "Now you have no choice – you *have* to invite Charlie now!" I'd rather that were not the case and no one has told me that it was.

But if, perchance, I should meet up with Jim in another lifetime, I'll shake his hand, offer him a cold IPA, and say "Jim, I owe you."

# PART 2

# AN OVERVIEW OF THE GENERAL AREA

# Geography

The Sierra Nevada stretches from the Susan River[9] and Fredonyer Pass[10] in the north to Tehachapi Pass in the south.[3] It is bounded on the west by California's Central Valley and on the east by the Basin and Range Province. Physiographically, the Sierra is a section of the Cascade-Sierra Mountains province, which in turn is part of the larger Pacific Mountain System physiographic division.

Position of Sierra Nevada inside California

West-to-east, the Sierra Nevada's elevation increases gradually from the California Central Valley to the crest, while the east slope forms the steep Sierra Escarpment. The range is drained on its northwest slopes by the Sacramento River and to the west-southwest by the San Joaquin River, two major Central Valley watercourses that ultimately discharge to the Pacific Ocean. Smaller rivers of the west slope include the Feather, Yuba, American, Mokelumne, Stanislaus and Tuolumne. The southern part of the mountains are drained by four rivers called the Kings, Kaweah, Tule, and Kern. These rivers flow into an endorheic basin called Tulare Lake, but historically joined the San Joaquin during wet years.

To the east, the melting snow of the mountains forms many small rivers that flow out into the Great Basin of Nevada and eastern California. From north to south, the Susan River flows into intermittent Honey Lake; the Truckee River flows from massive Lake Tahoe into Pyramid Lake; the Carson River runs into Carson Sink; the Walker River into Walker Lake; Rush, Lee Vining and Mill Creeks into Mono Lake; and the Owens River into the dry Owens Lake. None of the east-side rivers reach the sea; however, many of the streams from Mono Lake southwards are diverted into the Los Angeles Aqueduct and their water shipped to Southern California.

The height of the mountains in the Sierra Nevada increases gradually from north to south. Between Fredonyer Pass and Lake Tahoe, the peaks range from 5,000 feet (1,500 m) to more than 9,000 feet (2,700 m). The crest near Lake Tahoe is roughly 9,000 feet (2,700 m) high, with several peaks approaching the height of Freel Peak [10,881 feet (3,317 m)]. Further south, the highest peak in Yosemite National Park is Mount Lyell [13,120 feet (3,999 m)]. The Sierra rise to almost 14,000 feet (4,300 m) with Mount Humphreys near Bishop, California. Finally, near Independence, Mount Whitney is at 14,505 feet (4,421 m), the highest point in the contiguous United States.

South of Mount Whitney, the range quickly dwindles. The crest elevation is almost 10,000 feet (3,000 m) near Lake Isabella, but south of the lake, the peaks reach only to a modest 8,000 feet (2,400 m).[11]

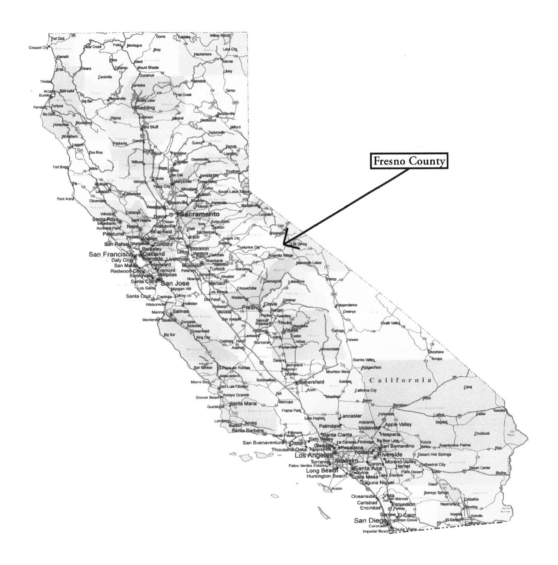

Fresno County

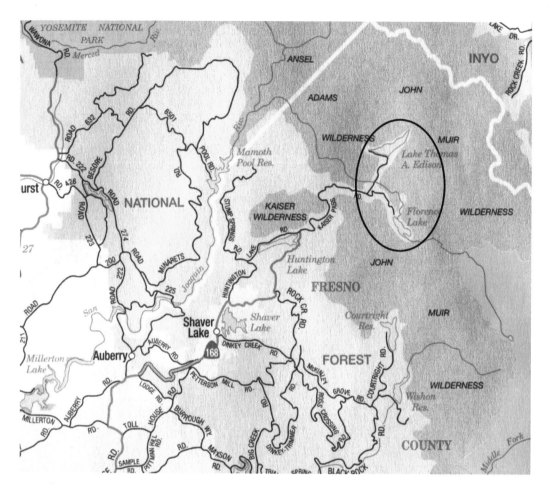

The ellipse drawn on the map above draws attention to two landmarks of importance as we close in on our destination, the Sally Keyes Lakes: Lakes Thomas

A. Edison and Florence Lake. They even seem unusually prominent in the very large area designated as the Ansel Adams and John Muir Wilderness. When dealing with information presented on a map, scale can be of utmost importance, as demonstrated in the next map.

We were packed in through meadows, then forest, then the transition to tree line. We camped at Sally Keyes Lakes, still in trees, with the campsite at about xxx feet in elevation and but a few steps from John Muir's Trail and near Mount Senger at xxxx feet. We visited Three Island Lake, passed close to Medley, Sandpiper, and Rose Lakes, but fished mostly in Marie and Heart Lakes. We took a look at the fish- barren and nameless cirque lake beneath Mount Hoover, and marveled at the view from there to the southeast, across seemingly endless miles over the ridge of the Sierran Range

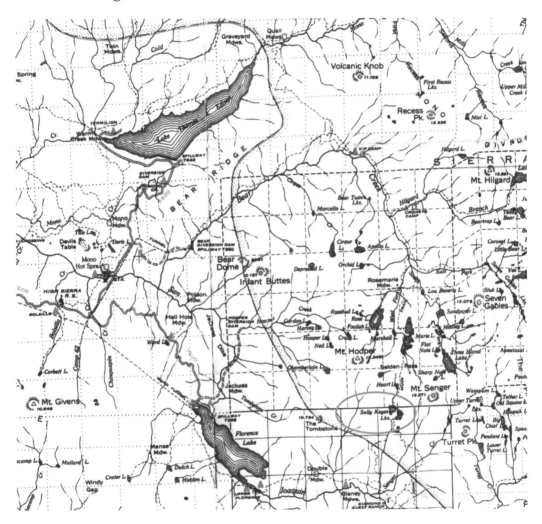

Selden Pass was at the highest elevation on the parts of the Trail we travelled. The larger map on the next page presents an amplified version of a part of the above map, including topographic contours. It shows that while we had a few short climbs to make, most of the daily travel was at near-level or on gentle grades.

Red arrow points to the "Cirque Lake

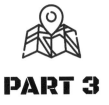

# PART 3

# THE LAKES

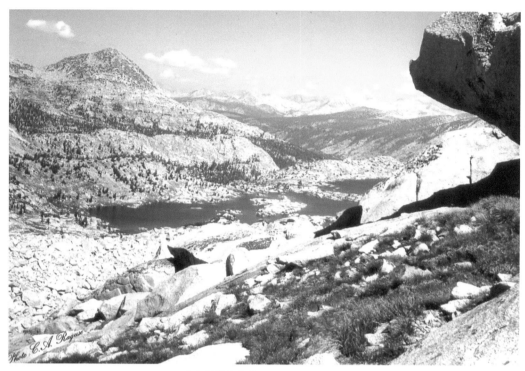

SALLY KEYES LAKES

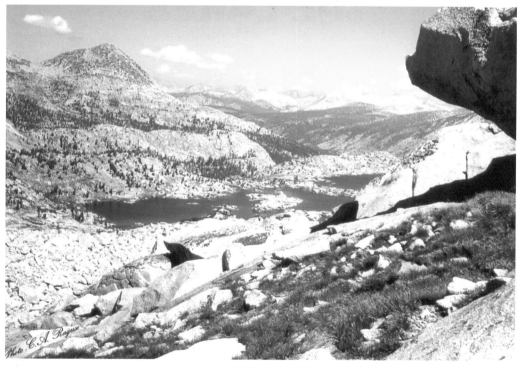

MARIE LAKE

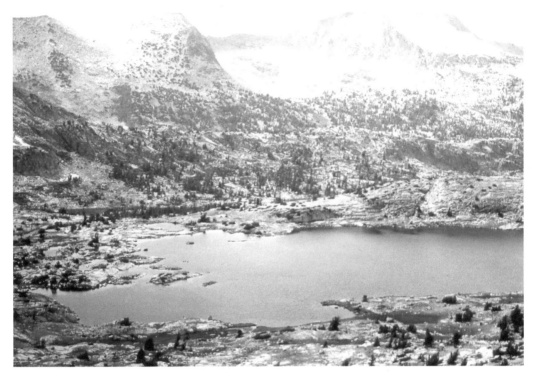

NORTH END OF MARIE LAKE

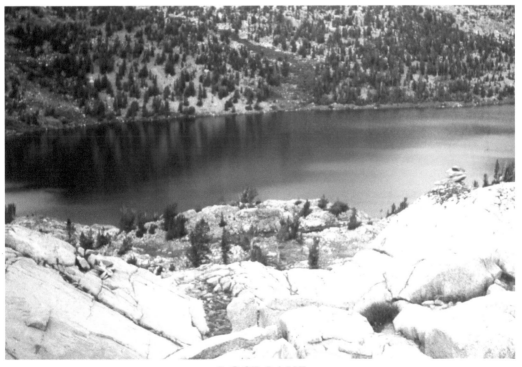

ROSE LAKE

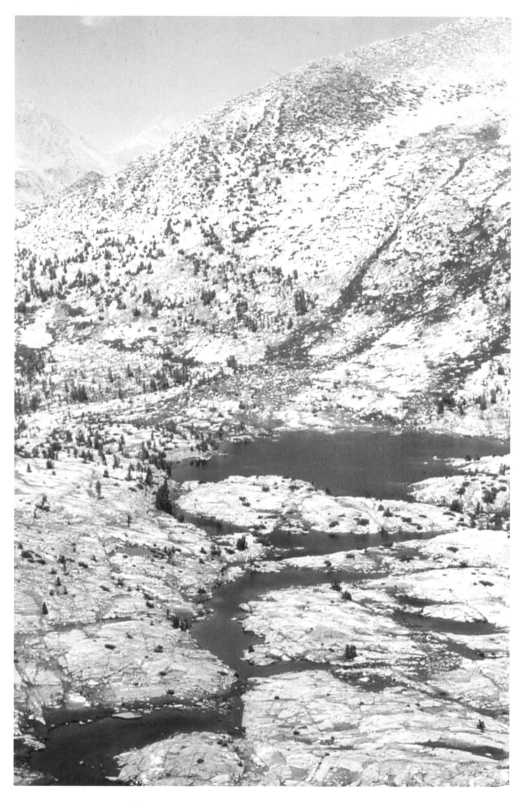

SANDPIPER AND MEDLEY LAKES

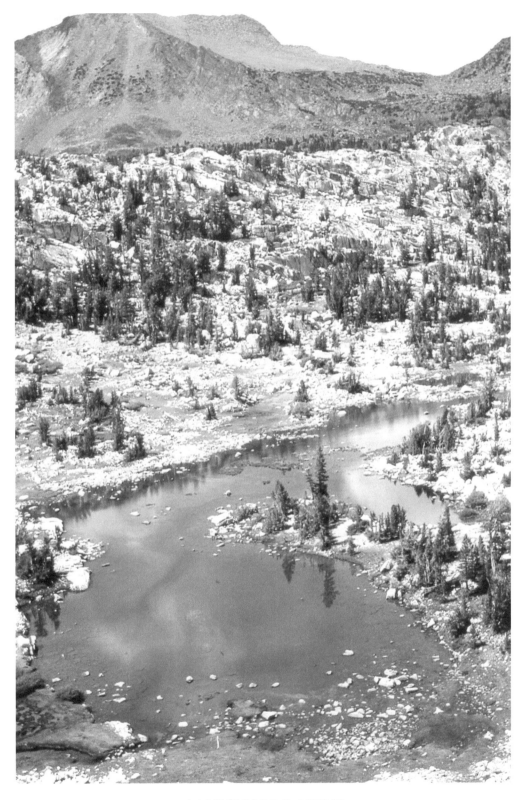

MARSHALL LAKE II

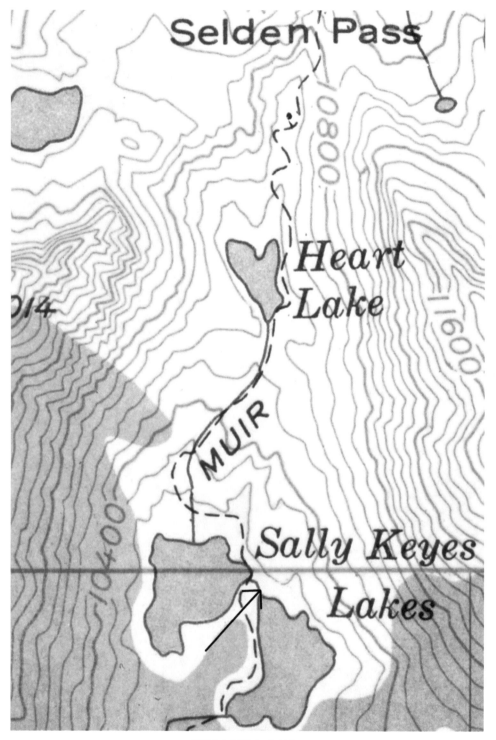

HEART LAKE

Arrow points to the location of our campsite. I do not have a general-area photo of Heart Lake, except its edges, which instead show the fishermen and their catches. (For these, see PART 10, page 58.)

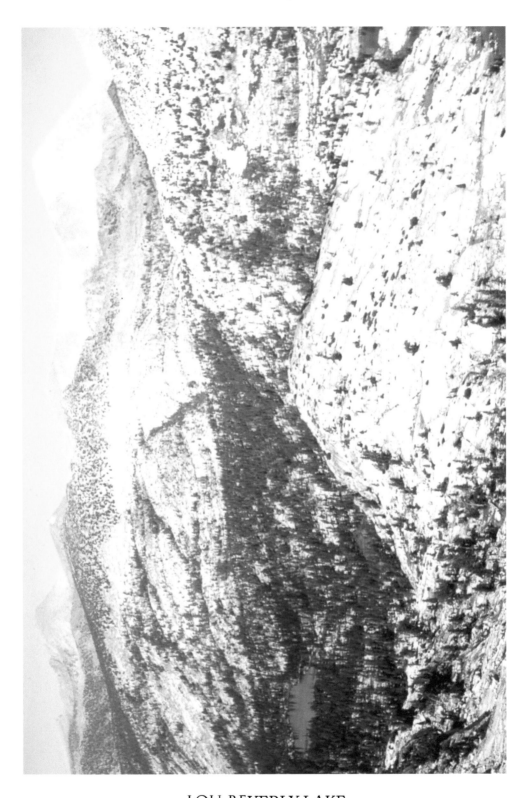

LOU BEVERLY LAKE

# PART 4

# THE MOUNTAINS

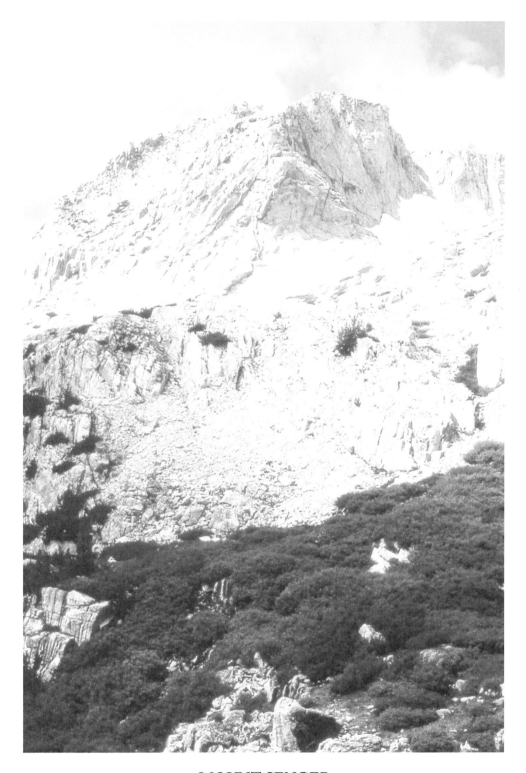

MOUNT SENGER

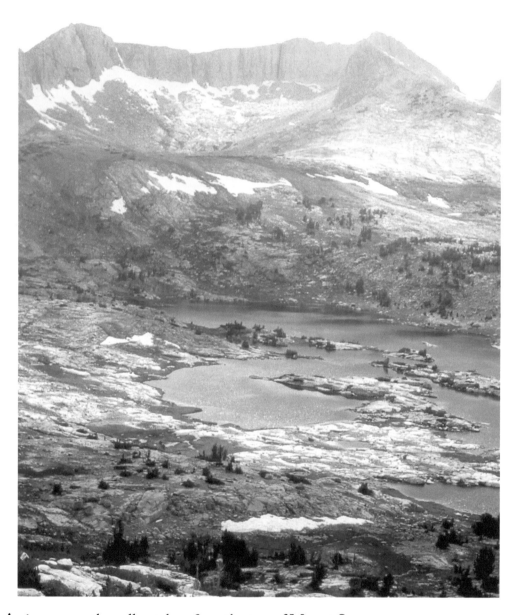

A view across the valley, taken *from* the top of Mount Senger

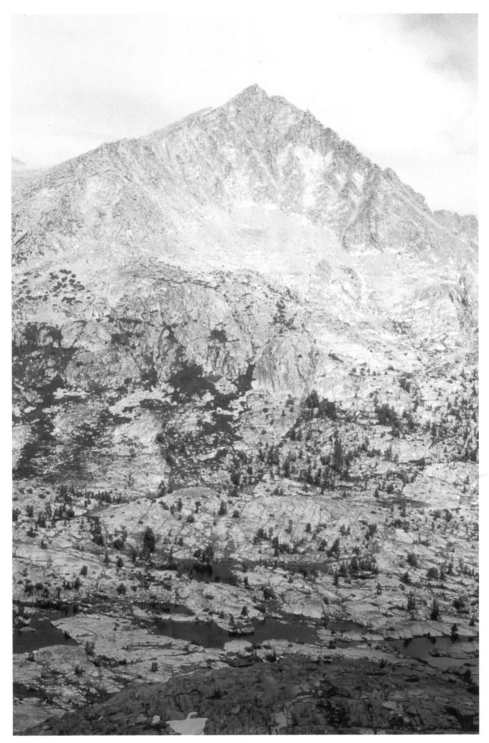

## MOUNT HOOPER

A view *from* Mount Senger *to* Mount Hooper, the *other* mountain: In Mount Hooper's lap, hidden from this view, lies another lake, an -unnamed cirque lake.

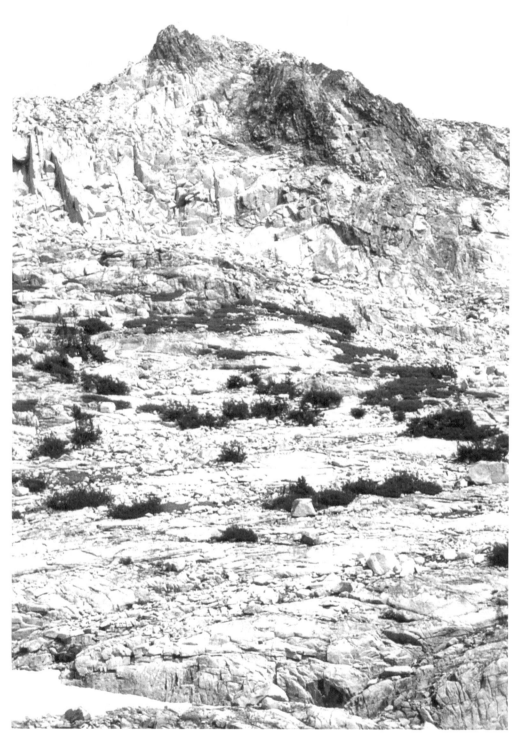

A glacier-carved valley above tree level.

# PART 5

# A CIRQUE LAKE AND THE VIEW FROM MOUNT HOOPER

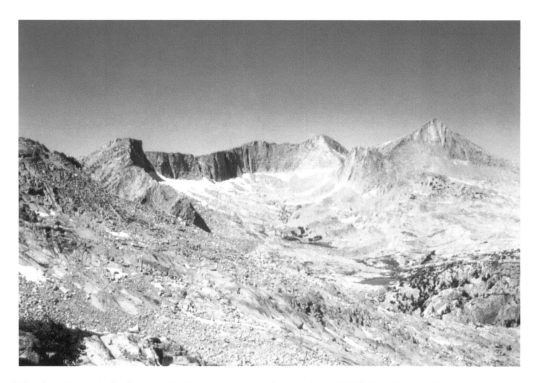

The background above: A classic cirque formation. Hidden from this view is the tiny cirque lake, shown in the image below. Unidentified, we called it "No-Name Lake". Recently, poring over the Forest Sservice map (pg. 9), I discovered there actually *is* a Cirque Lake, farther north but still here in Fresno County, Cailf.

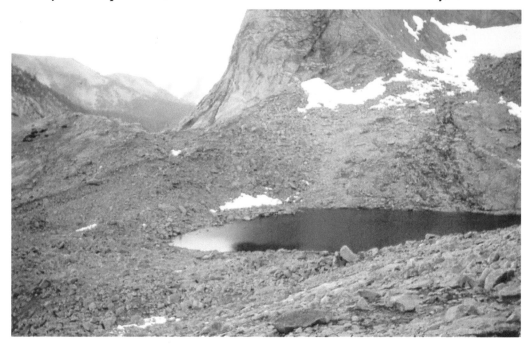

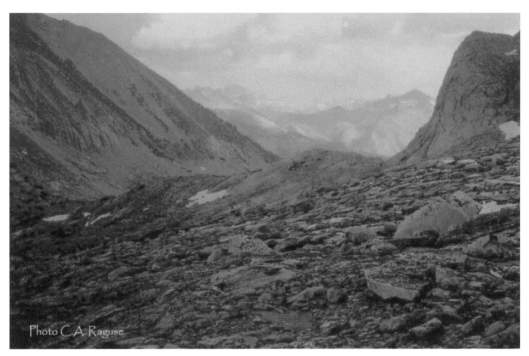

At Mount Hoover.

A small part of the photo above. An awe-inspiring view of the Sierra Range crest.
If'n you could lay a level on it I'll bet the needle would peg on zero.

## PART 6

# THE (Human) CAST

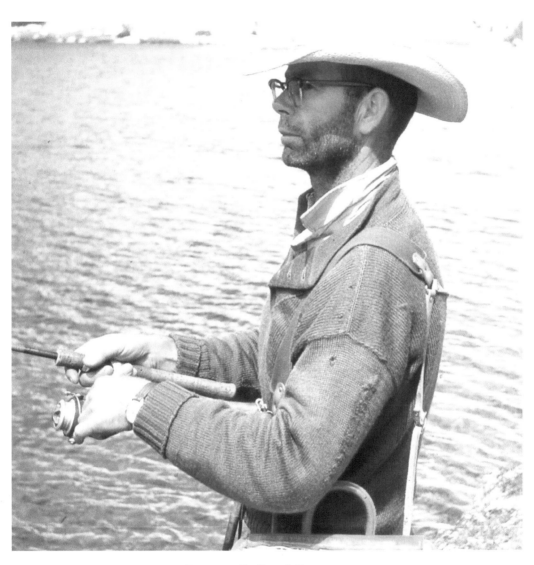

JAMES E. 'JIM' STREET

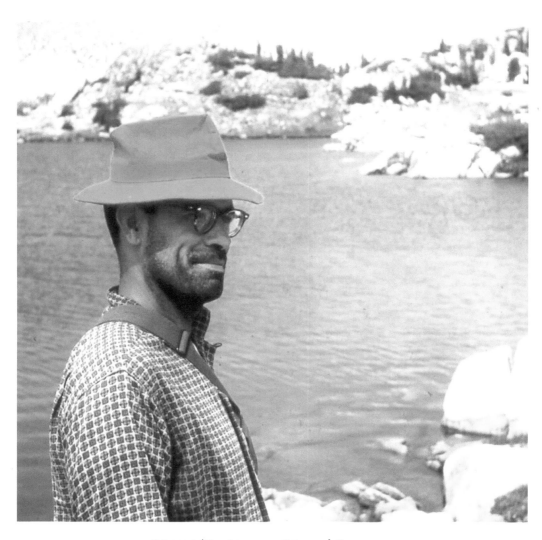

John 'Brother John' Street

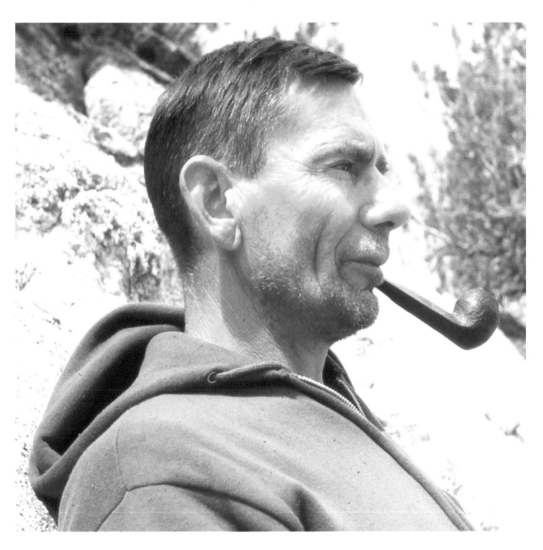

ANTHONY 'TONY' HOLLAND

Charles 'Charlie' Raguse

# PART 7

# AT THE PACK STATION

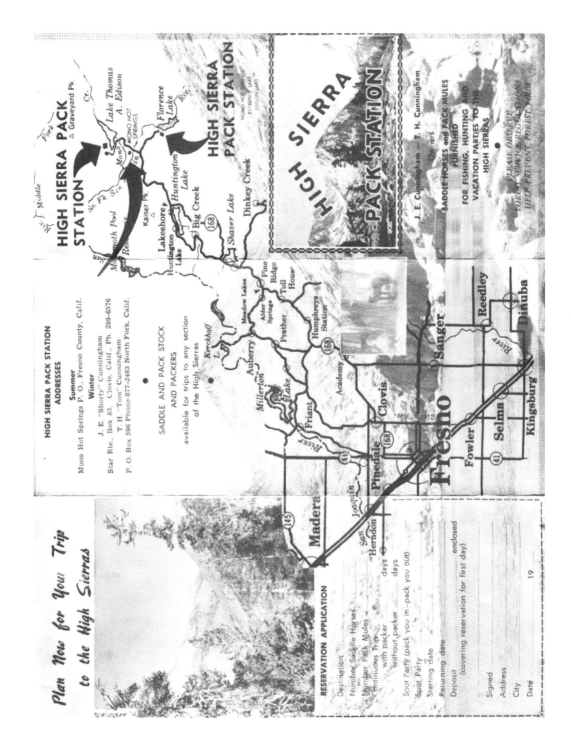

*Plan Now for Your Trip to the High Sierras*

**HIGH SIERRA PACK STATION**

**HIGH SIERRA PACK STATION ADDRESSES**

**Summer**
Mono Hot Springs P. O., Fresno County, Calif.

**Winter**
J. E. "Shorty" Cunningham
Star Rte., Box 83, Clovis, Calif., Ph. 299-6576
T. H. "Tom" Cunningham
P. O. Box 396 Phone 877-2483 North Fork, Calif.

SADDLE AND PACK STOCK
AND PACKERS

available for trips to any section
of the High Sierras

**HIGH SIERRA PACK STATION**

SADDLE HORSES and PACK MULES
FURNISHED

FOR FISHING, HUNTING AND
VACATION PARTIES TO THE
HIGH SIERRAS

J. E. Cunningham — T. H. Cunningham
Owners

**RESERVATION APPLICATION**

Destination
Number Saddle Horses
Number Pack Mules
Continuous Trip _____ days
    with packer _____ days
    without packer

Spot Party (pack you in—pack you out)
Spot Party
Starting date
Returning date

Deposit _____ enclosed
    (covering reservation for first day)

Signed
Address
City
Date _____ 19

30

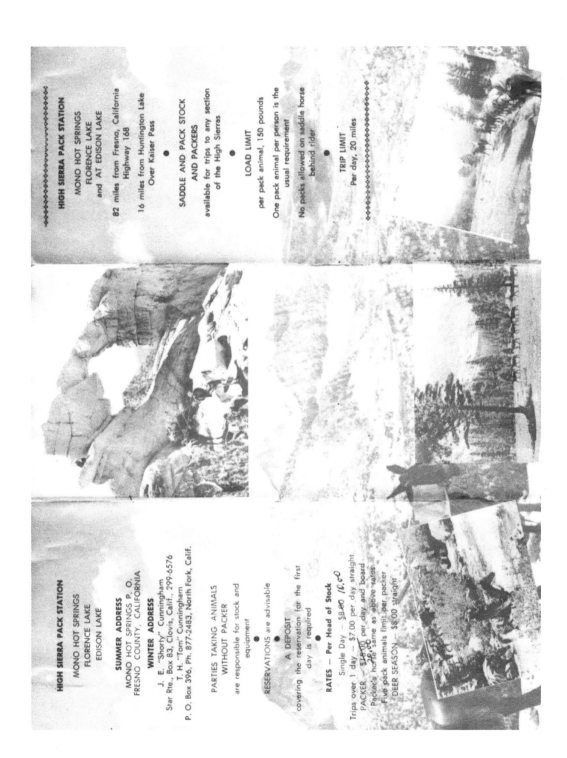

## HIGH SIERRA PACK STATION

MONO HOT SPRINGS
FLORENCE LAKE
and AT EDISON LAKE

82 miles from Fresno, California Highway 168

16 miles from Huntington Lake Over Kaiser Pass

SADDLE AND PACK STOCK AND PACKERS

available for trips to any section of the High Sierras

LOAD LIMIT

per pack animal, 150 pounds

One pack animal per person is the usual requirement

No packs allowed on saddle horse behind rider

TRIP LIMIT
Per day, 20 miles

## HIGH SIERRA PACK STATION

MONO HOT SPRINGS
FLORENCE LAKE
EDISON LAKE

### SUMMER ADDRESS
MONO HOT SPRINGS P. O.
FRESNO COUNTY, CALIFORNIA

### WINTER ADDRESS
J. E. "Shorty" Cunningham
Star Rte., Box 83, Clovis, Calif., 299-6576
T. H. "Tom" Cunningham
P. O. Box 396, Ph. 877-2483, North Fork, Calif.

PARTIES TAKING ANIMALS WITHOUT PACKER are responsible for stock and equipment

RESERVATIONS are advisable

A DEPOSIT covering the reservation for the first day is required

### RATES — Per Head of Stock

Single Day — $8.00 10.00

Trips over 1 day — $7.00 per day straight

PACKER — $18.00 per day and board

Packer's horse same as above rates

Five pack animals limit per packer

DEER SEASON — $8.00 straight

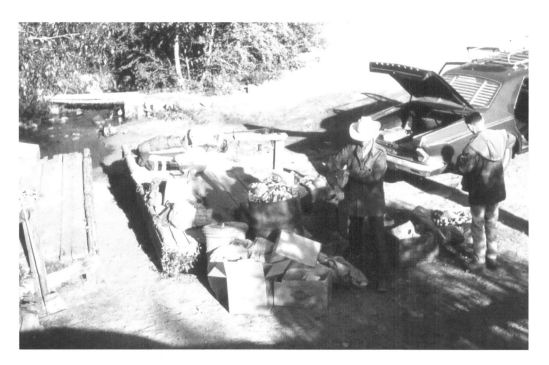

Arrival at the High Sierra Pack Station

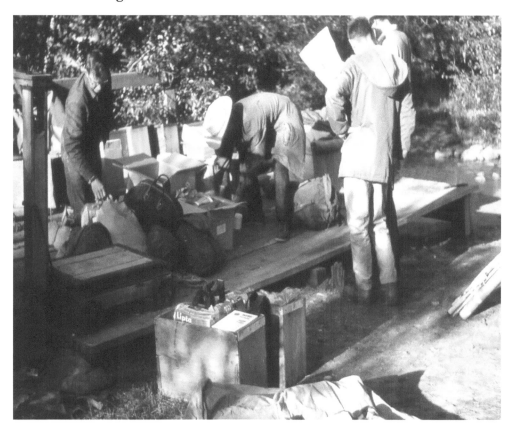

Weighing out equal-weight parcels for the trip in.

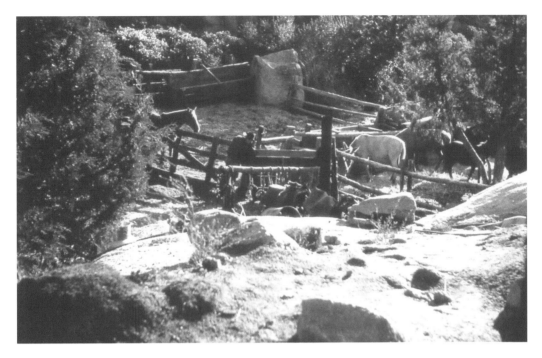

The corral. Home for the draft mules and riding horses.

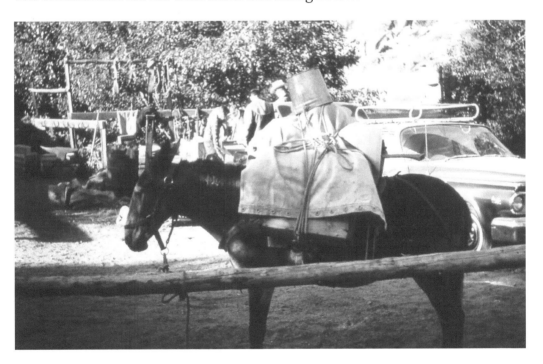

All dressed up and ready to canter.

# PART 8

# THE TRIP IN

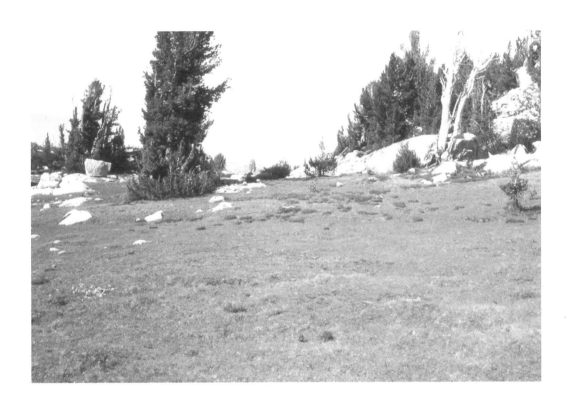

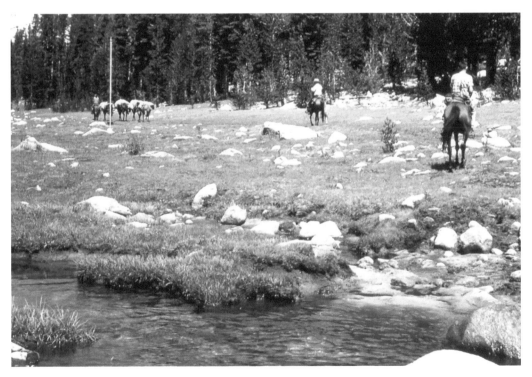

On our way. Two views soon after leaving camp.

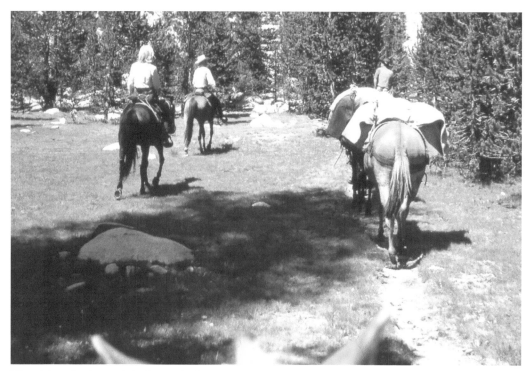

The blonde-haired lady and the man in a red shirt are High Sierra Pack Station employees. They will bring the horses and mules back.

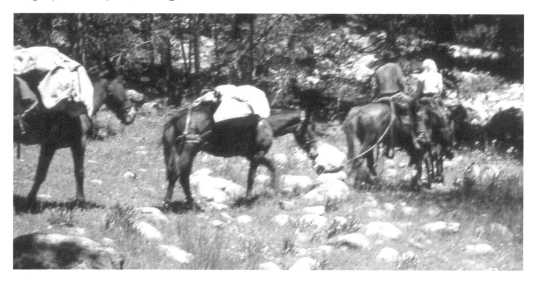

"On the road again!" sing the mules

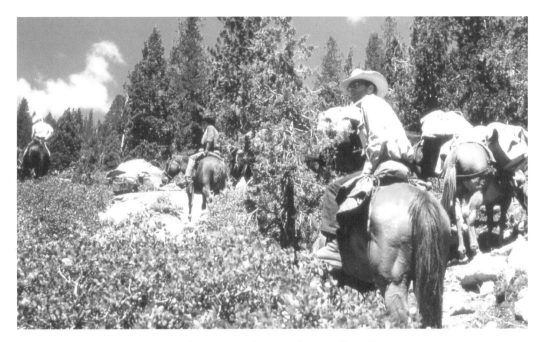

Entering rough country and a sparse forest of trees. Jim Street.

A "manufactured" trail through the wooded area. Neat, huh?

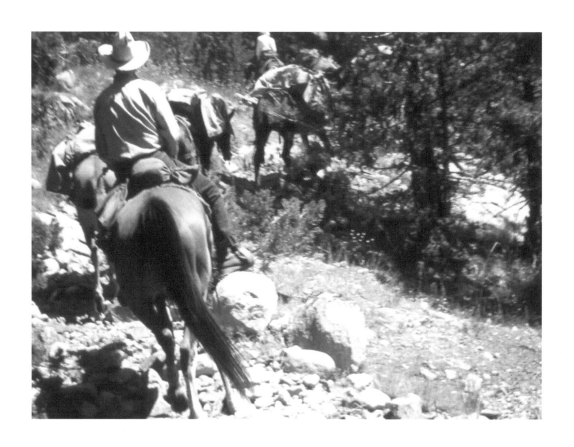

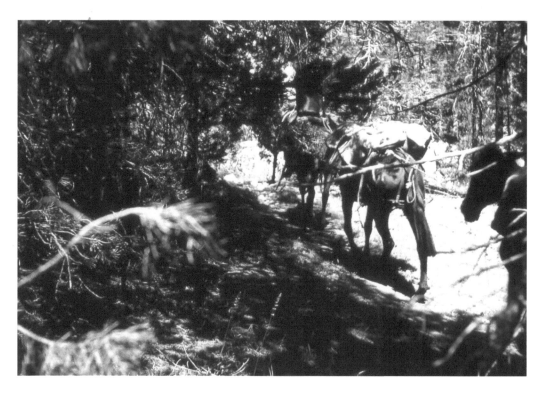

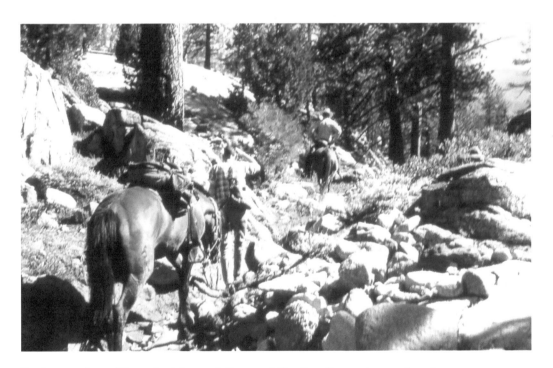

In front of me, Tony decides to hike a while. Jim Street is up ahead.

# PART 9

# SETTING UP CAMP

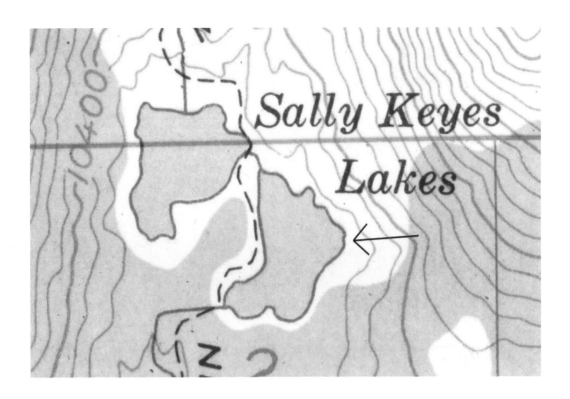

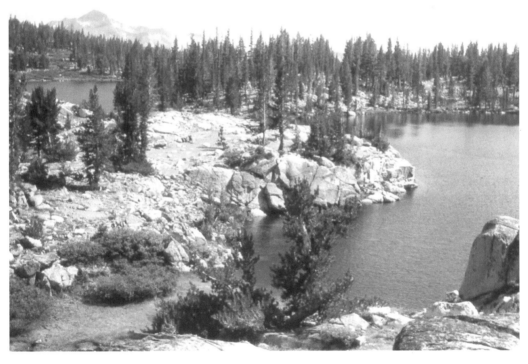

Our campsite was a few steps behind where I took this picture. The arrow in the topo map above point to the same bulge you see on the right side of the Trail, which is identified by the dashed line. At upper left, the other Sally Keyes Lake is visible.

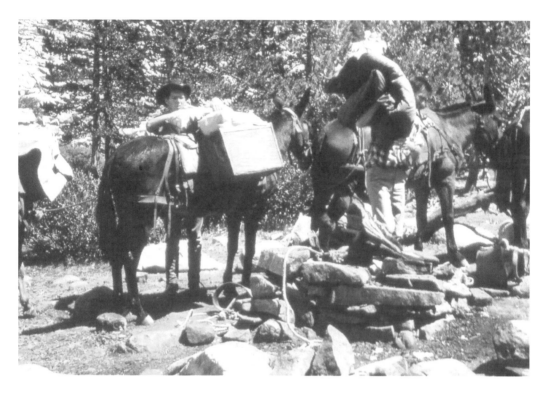

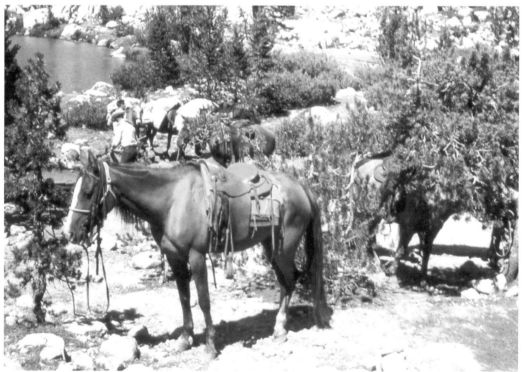

Unpacking and settling in. No, that horse won't run away. Its reins are grounded

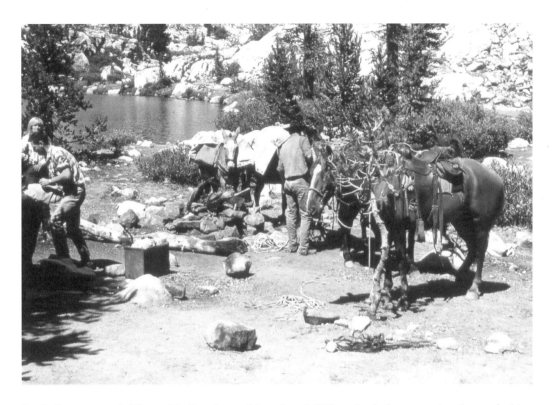

Left foreground: Tony Holland working hard. We asked the man in the red shirt and tan vest if the pretty blonde lady could stay. He said *"No"*.

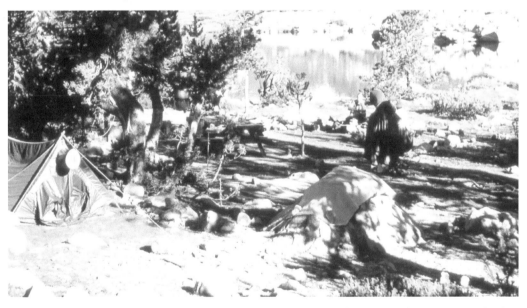

A general view of much of the campsite. "Brother John" chose to bring a tent for his bedroom. A Sally Keyes Lake in the near distance.

# PART 10

# FISHING

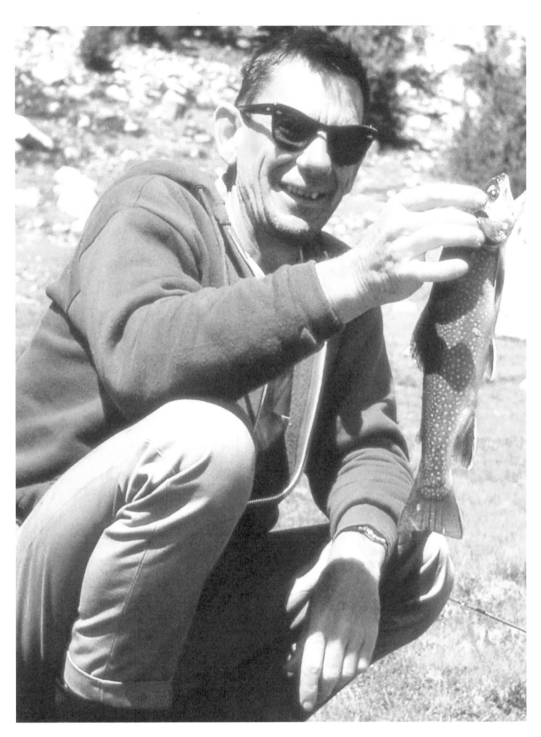

And Tony won the prize!

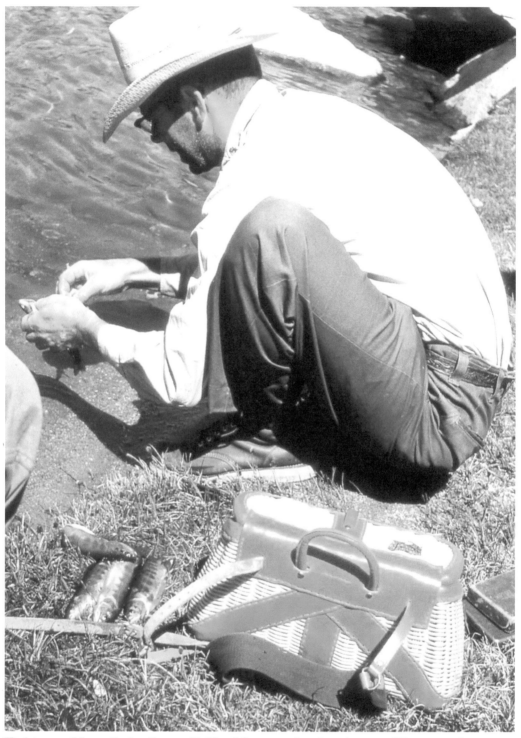

Fishing at Heart Lake. James E. "Jim" Street is hauling 'em in. Classy creel too.

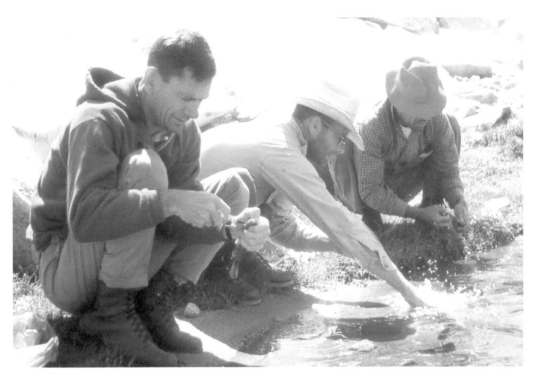

Left to right: Tony Holland, Jim & John Street

Putting just-caught fish into a convenient daytime refrigerator

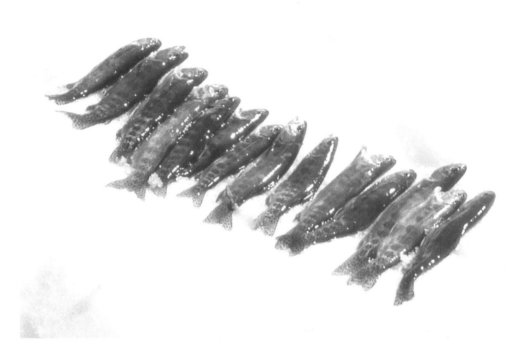

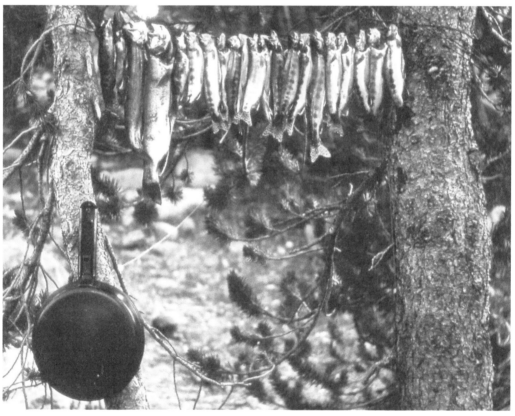

The day's catch at campsite, and the frying pan awaits. The lunker you see up there belonged to Tony; next largest to Jim Street

# PART 11

# EATING

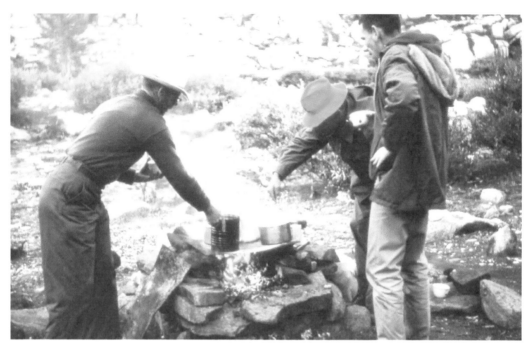

The Kitchen.

Necessities: Cutlery, Cigars, and the Menus . Jim Street's contribution.

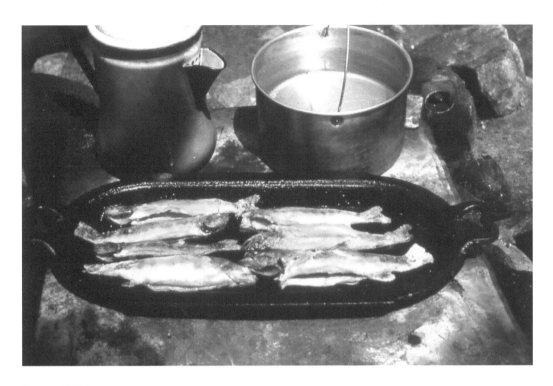

Pay-off: It's supper time.

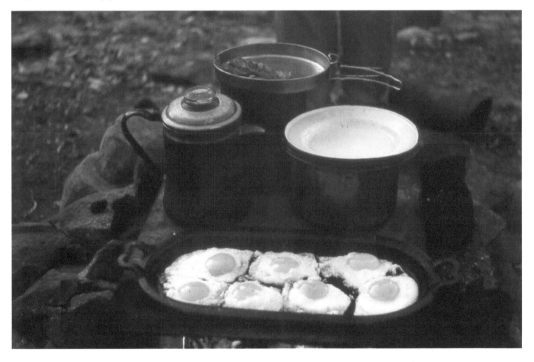

Better'n Woodland's Country Waffles any time.

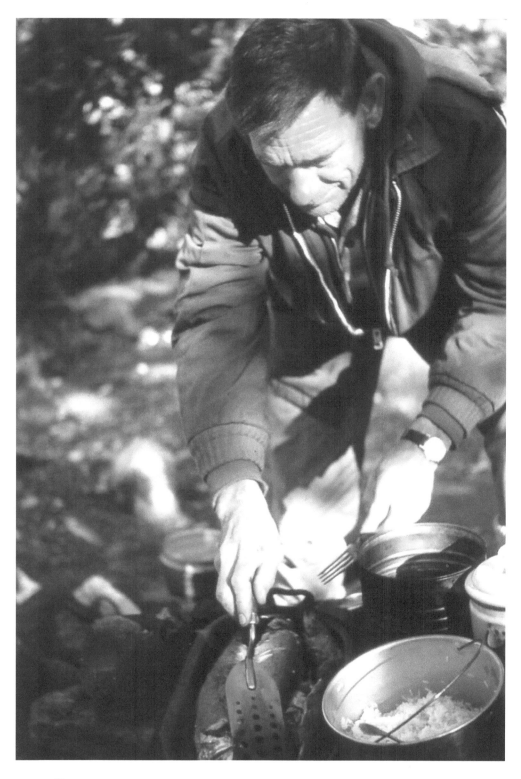

Stay ...*Stay!*"

# PART 12

# THE FIREWOOD TREE

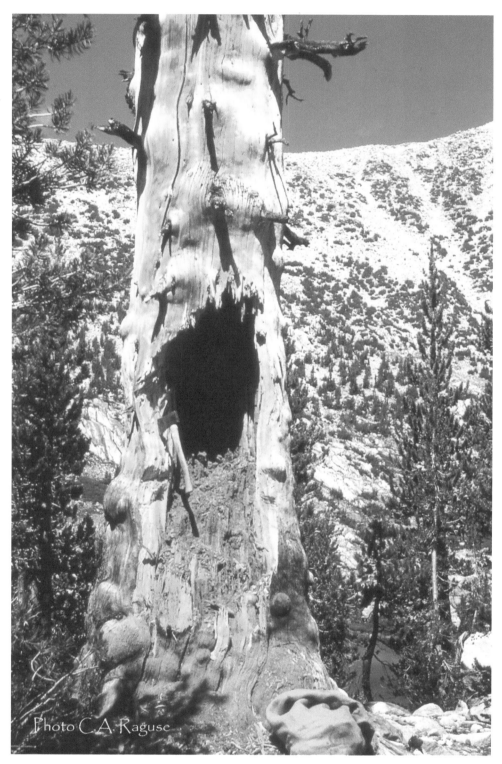

With axe in hand, many souls have visited here.

No, I didn't lose my camera; It was just on loan to get my picture took. (And no, we weren't unduly harming the environment)

# PART 13

# SLEEPING

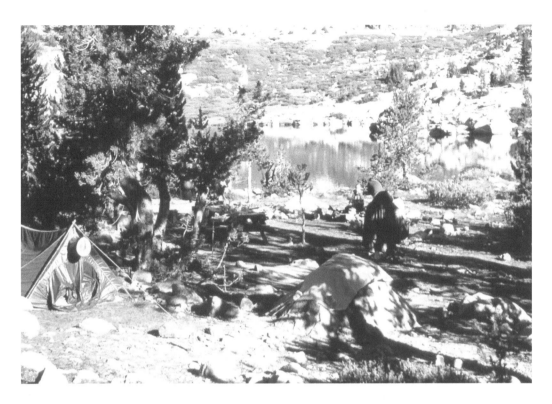

"Brother John" opted for a tent. One of the Sally Keyes Lakes in the background.

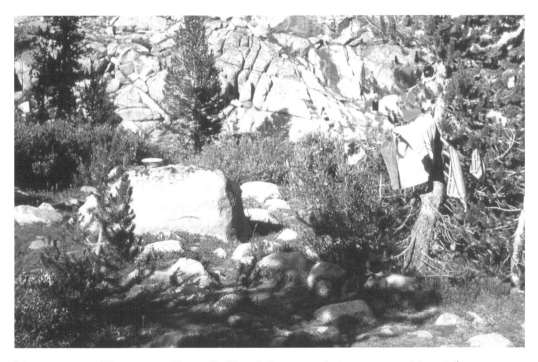

The morning "Spruce-up Room". (But I forgot to bring my toothbrush!)

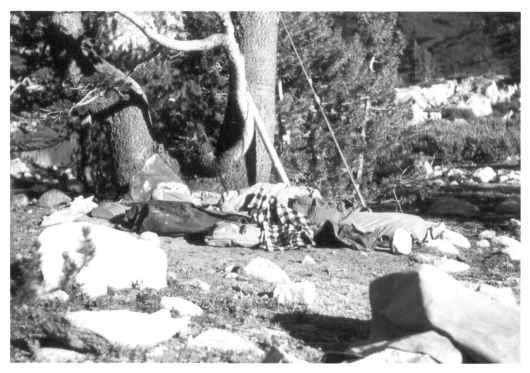

Looks like my camera case and knapsack, so it must have been my bedroom choice.
? ? had loaned a leaky old military sleeping bag to me, and it was cold at night. I
soon took only my boots off before bedtime.

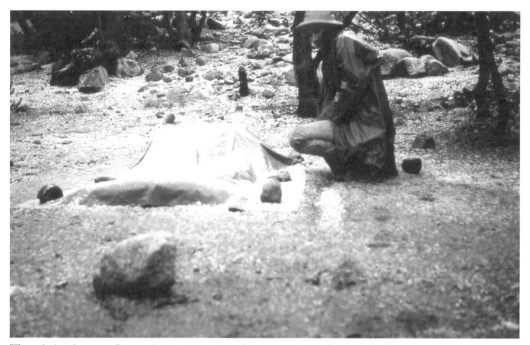

Tony's bedroom. Less than inviting after returning "home" after a mountain storm
had prevailed that day..

# PART 14

# ON THE TRAIL

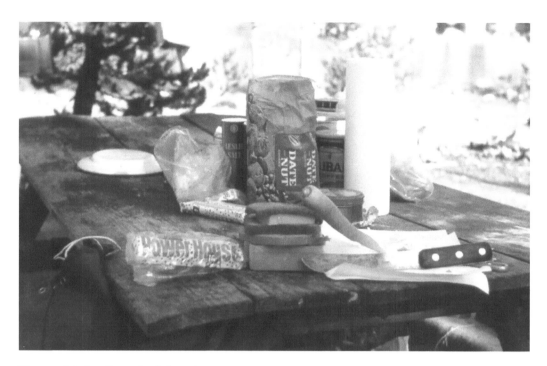

The makin's of my day's lunch

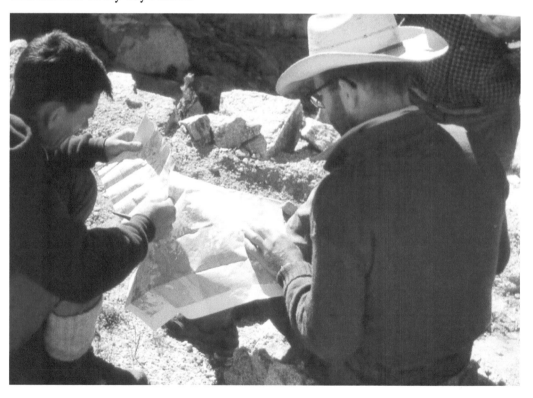

*Nothing* beats the USGS Quads; in this case, Mt. Abbot, California, 1953

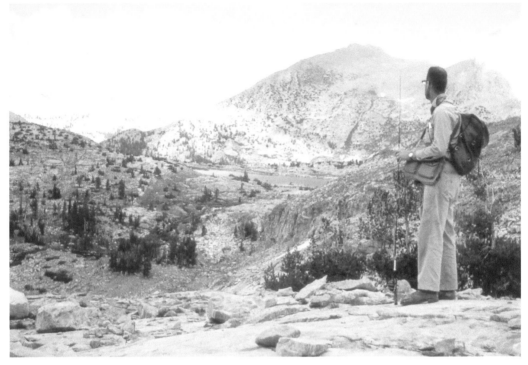

Where, and when, it seems that you can see forever

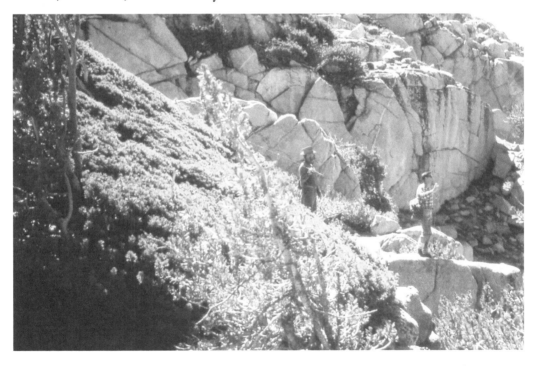

Tony Holland: "You can't *get* there from here.' John Street (in red hat) demurs: "There's got to be a way" he says.

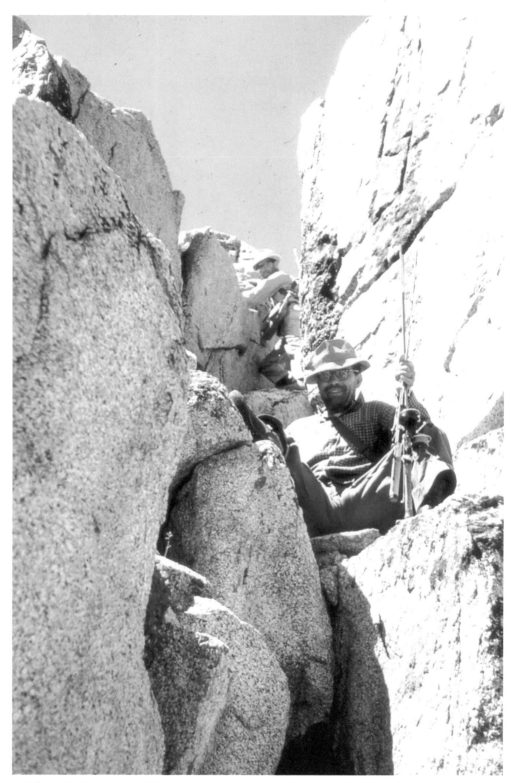

I *told* you I's find a way! The guy up top looks like he's afraid to come down.

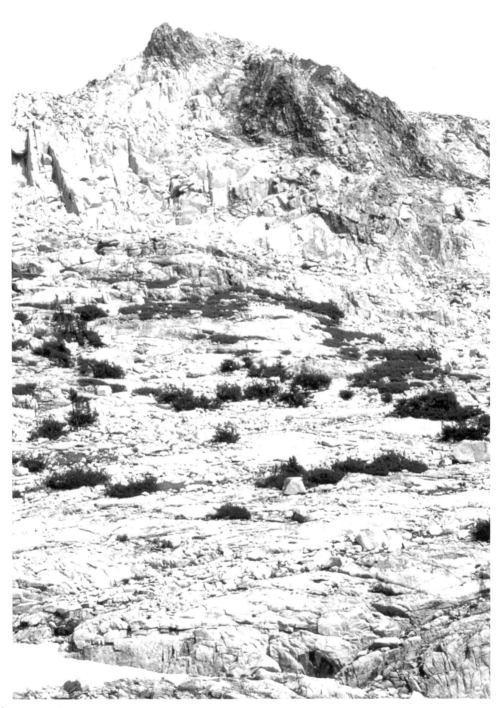

Awesome!

Midway on Marie Lake. There are two fisher-people here –can you find them?

This *is* a trail (note the duck that marks it), but whether it is the trail John Muir walked on is a matter of conjecture.

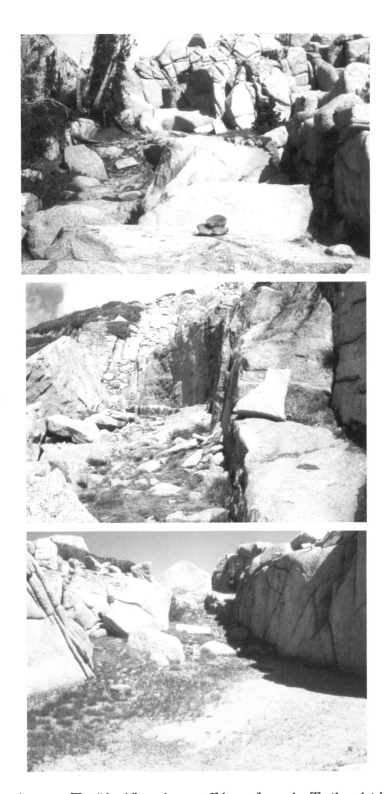

From top to bottom: The "duck" marks an offshoot from the Trail, as laid-out on the map. Who knows? *This* may have been the original trail.
Note Mount Hoover, framed at the top of the bottom picture.

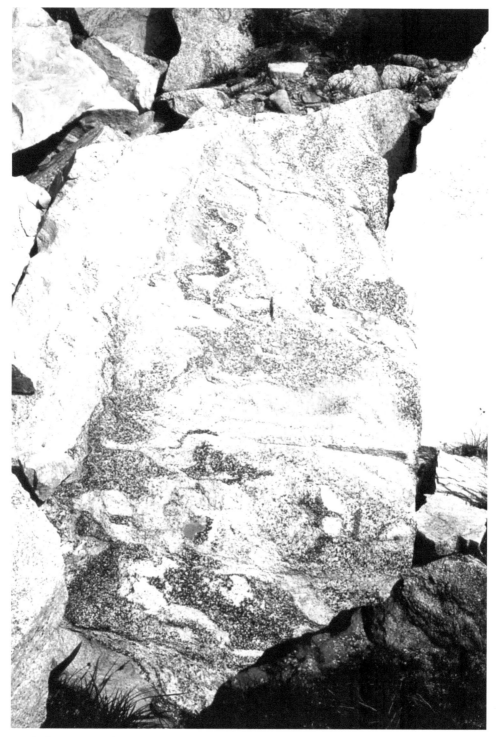

Revealed in stone: A portrait capturing geology's inner writhing. The slab is roughly 3 feet long by 2 feet wide.

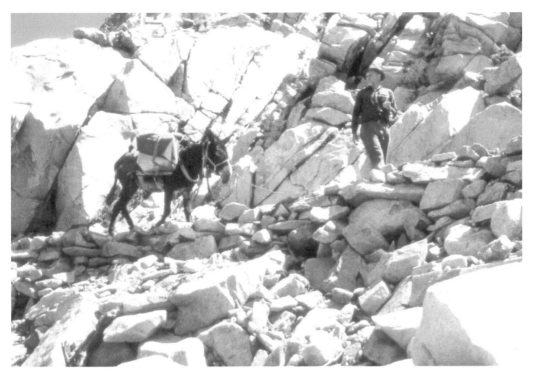

On John Muir Trail, a sole pair of travelers.

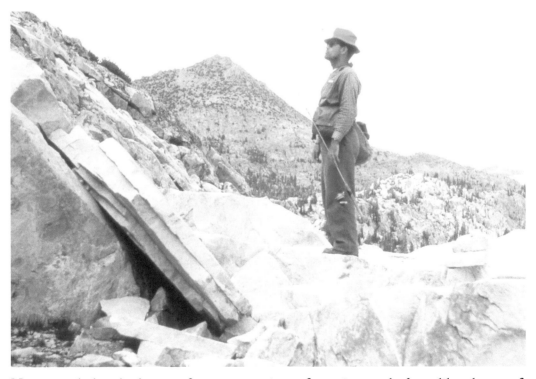

Note equal-the thickness of an aggregation of granite stacked up like sheets of paper. Brother John apparently contemplates the slope level. "There *has* to be a way around."

## PART 15

# A DAY IN CAMP

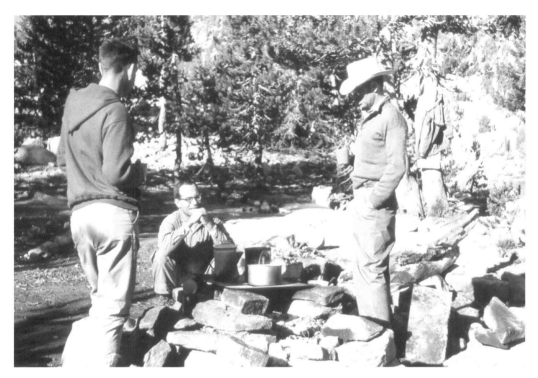

The previous day had produced an early-winter storm. It hampered fishing activities and covered Tony's exposed bed site with its own blanket of white (see page 41). But today brought clear skies and warm sun, a perfect day to stop, rest, drink coffee and tell stories.

Also, Jim, taking a hurried step, slipped on the surface of a rough-edged stone, cutting an ugly gash on his ankle for the effort. My preparations for this trip included a makeshift first-aid kit, including bandages.

I offered to administer one to Jim's injury: A "Butterfly" bandage. Returning from the trip Jim checked with a doctor as to his injury.

The doctor found it to be healing well, and asked Jim if he wished to have it re-bandaged for protection. Jim, straight-faced as only Jim could be, responded "Dr. Raguse suggested a butterfly bandage."

And that was exactly what he got.

# PART 16

# SPECIAL MOMENTS

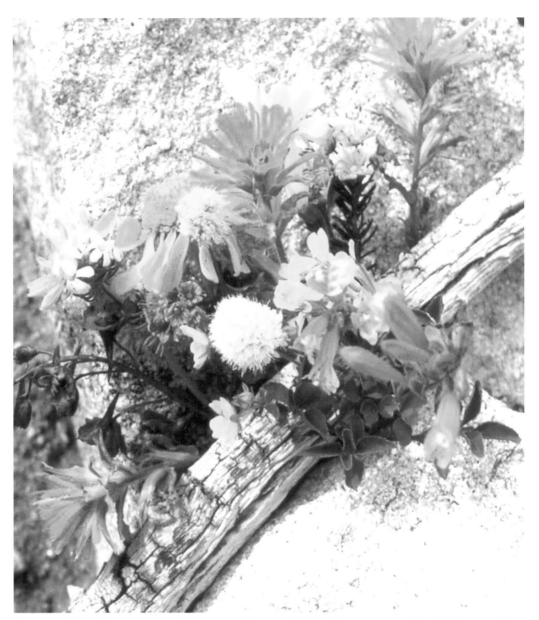

Arranged to take a summer's bouquet home. A bit of open ground lay below; a place for the ripening seeds to gather. I wonder if future passersby might see a cluster of these many kinds of mountain beauties, and wonder why there were so many altogether in such a small place.

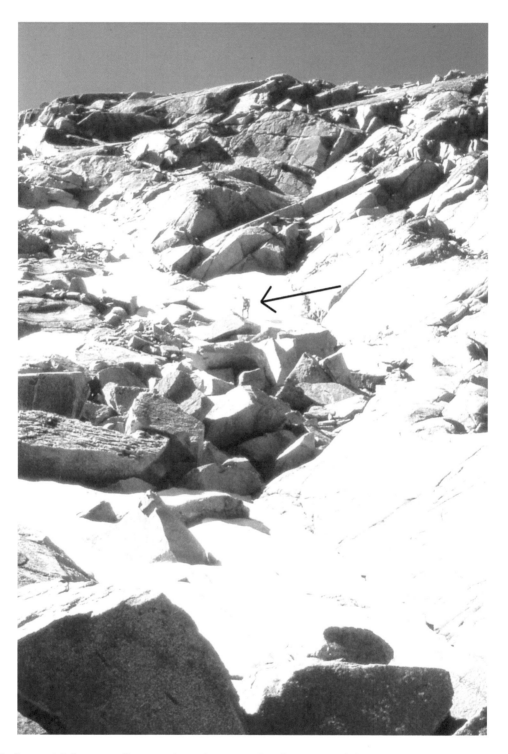

A Special Moment: It must have been so for Australian Tony Holland, who opted to make this arduous climb to frame a picture of him amidst the encompassing mass of white granite.

An image certain to remain as a part of his family's treasures for all time.

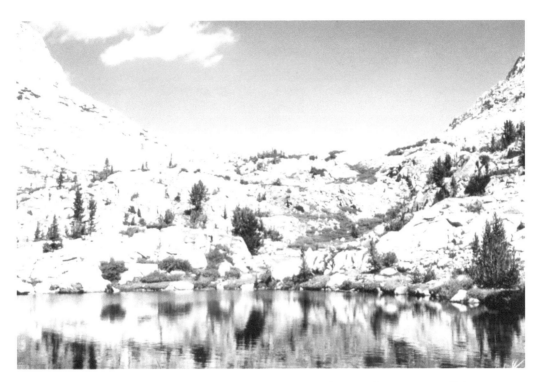

The gentle arc of the skyline is what grabs you, as it leaves the imprint of the massive glacier that carved this little valley out of solid granite.

***Real***, pure, ***<u>natural</u>*** water, ***<u>not</u>*** the kind that comes out of a shopping-center wall.

# PART 17

# MISCELLANEOUS

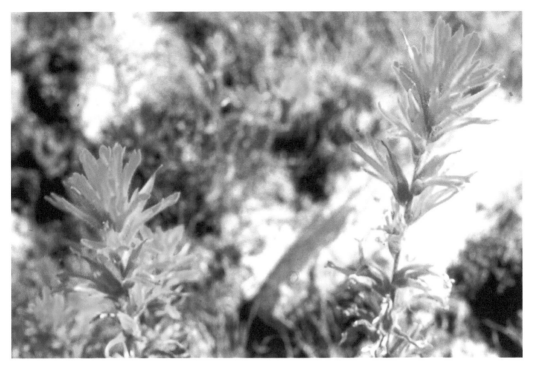

I think the name of this flowering plant is "Mountain Paintbrush".

"So far up the mountain, but *no* farther." Note the thickened tree stumps in an aged stand, and, by the way, that's *my* hat in the foliage, put there for scale.

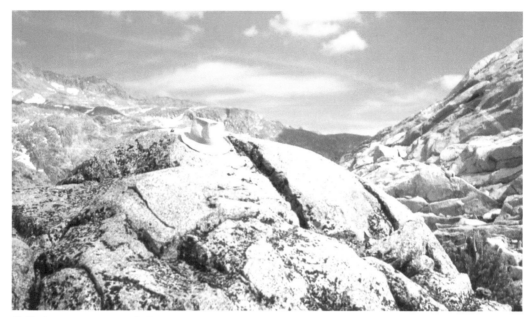

(My hat gets around! But *here* at the absolute top of Mount Senger?!)

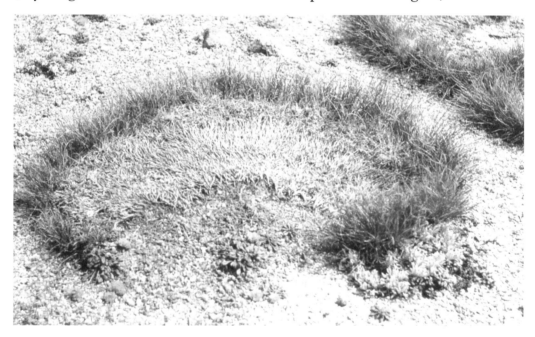

A "Fairy Ring". A wind- or water-blown bit of seed took root here a long time ago. As it grew, the roots of the tiny plants scoured the substrate for necessary nutrients, ever moving outward to survive. None will follow, over the barren land left behind.

# PART 18

# EPILOUGE

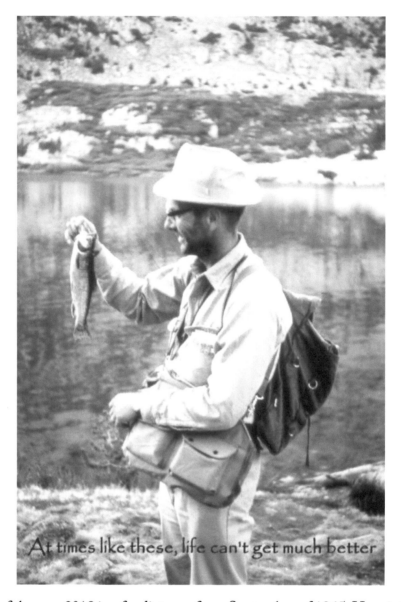

At times like these, life can't get much better

February of the year 2018 is a far distance from September of 1965. How is it that it took so long to write this. Both Jim and "Brother John" Street are long dead. I have tried to contact Tony Holland over the years, once replying to an Anthony Holland who had put something on the internet that enabled response. No replies.

I sometimes have the eerie feeling that folks I knew, and who knew me well, but now are long gone, watch what I am doing from time to time, and nudge me into thoughts and actions I probably might not otherwise take.

Who can say? But Jim, Brother John, Tony, if you have indeed been watching me craft this tale I say: Thank you for being part of it. It was indeed an epic journey.